Bluebell Wood

A scene infused with bright light and vibrant colour. I love walking through a bluebell wood on a spring morning, with that contrast of rich blue/violet and the fresh spring greens.

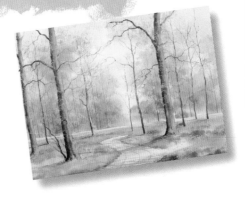

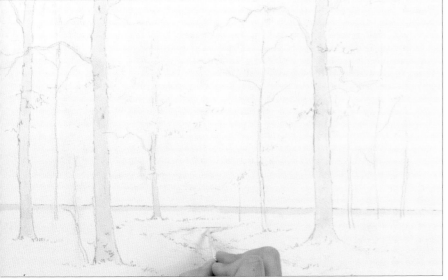

1 Transfer the scene on to watercolour paper as shown opposite. Apply masking fluid on the four main trees which catch the light, also to the line where the ground meets the distant trees and to the path.

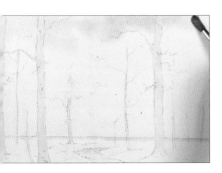

Tip

Use an old brush for masking fluid. Dampen it and rub it in soap before dipping it in the masking fluid. This ensures that the masking fluid will wash out easily after use and will not ruin the brush.

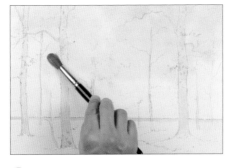

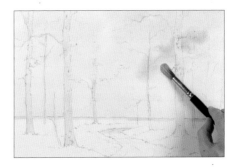

2 Mix a series of colours before beginning: cobalt blue and cobalt violet; a thin wash of cadmium lemon; a bright green from aureolin and cobalt blue; a darker green from aureolin, ultramarine blue and a touch of burnt sienna; and a warm grey from cobalt blue, cobalt violet and burnt sienna. Wet the top two-thirds of the painting with clear water and using a no. 16 brush, drop in the cobalt blue and cobalt violet mix to suggest a glimpse of sky.

3 Work quickly while the paint is wet. Drop in the cadmium lemon wash around the middle of the painting, letting it drift into the blue. Use the brush on its side to cover a large area quickly.

4 Add the bright green mix, still working wet in wet, on top of the cadmium lemon and into the sky area. Leave some of the yellow wash showing.

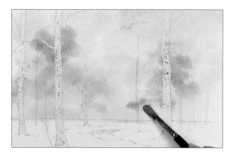

5 Still working wet in wet, float in the dark green a little more sparingly. Note that you are adding the colours from light to dark.

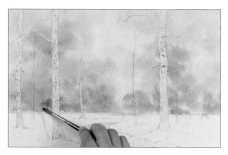

6 Change to the no. 8 brush and introduce the warm grey into the lower part of the distance, bringing it right down to the masking fluid. Do not take too long over these wet in wet stages. Allow to dry.

7 Use the side of the no. 10 brush and a fairly dry mix of aureolin and cobalt blue to suggest masses of leaves. Make some marks with a weaker mix to vary the effect.

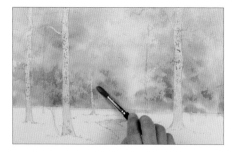

8 Do more dry brush work with the darker green mix, concentrating on the area lower down to provide a contrast with the lighter foreground.

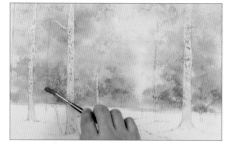

9 Change to the no. 8 brush and do more dry brush work with the warm grey mix just above the horizontal masking fluid. Allow the painting to dry.

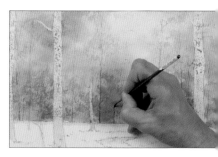

10 Using the no. 1 brush, paint distant trees with a grey mix of cobalt blue, cobalt violet and burnt sienna. Add water to the paint for some of the trees to vary the tone. You can add trees if you feel that the painting needs it; do not feel too restricted by the tracing.

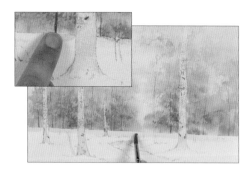

11 Rub the masking fluid off the horizon line but leave it on the trees. Mix your next selection of colours: a thin wash of cadmium lemon; a bluebell colour from cobalt blue and cobalt violet and spring green from aureolin and cobalt blue. Use the no. 10 brush to sweep the cadmium lemon wash over the middle distance.

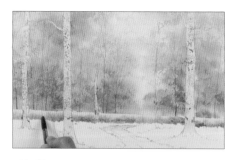

12 Clean the brush and pick up the bluebell colour. Lay it in while the yellow is still wet, allowing it to soften in. Strengthen the colour in places to vary the effect. Do not worry if the colours separate slightly as this enhances the effect.

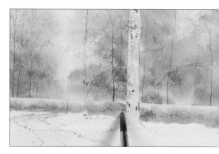

13 Clean the brush again and lay in the spring green before the bluebells dry.

Tip

Do not overwork the ground area. Allow the bluebell colour and the green to soften into each other without actually mixing, which can create a muddy green.

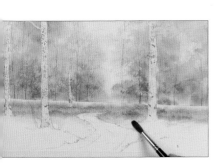

14 Continue laying in the bluebell colour and then soften the bottom of the paint with clean water so that no hard lines will form, allowing you to carry on working in this area later.

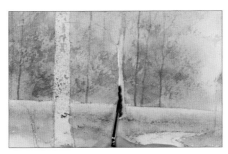

15 Remove the masking fluid from the middle distance trees. Mix raw sienna with a little burnt sienna for the light side and burnt sienna and cobalt blue for the dark side. Paint the light side in first using a no. 4 brush, then quickly paint the dark side, allowing the colour to drift into the lighter paint.

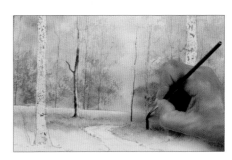

16 Paint the other middle distance trees, adding a few branches. The brush stroke for the trunk must become thinner at the top. If the brush becomes dry, the broken effect is useful for suggesting foliage over the trunks and branches.

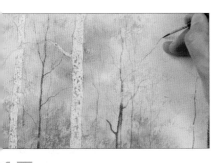

17 Use a no. 1 brush to paint fine branches coming from the middle distance trees. Do not overload the brush as this makes it difficult to paint fine lines.

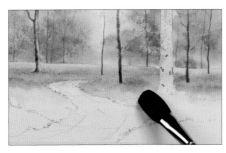

18 Mix more colours: cobalt blue and cobalt violet for bluebells; cadmium lemon for grass; spring green from aureolin and cobalt blue; dark green from aureolin, ultramarine blue and burnt sienna; and raw sienna and burnt sienna for foreground warmth. Use the large wash brush to wet the foreground with clean water.

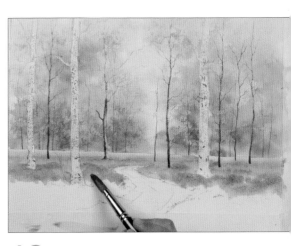

19 Working wet in wet and using the no. 10 brush, drop in the bluebell colour, leaving some white areas of unpainted paper.

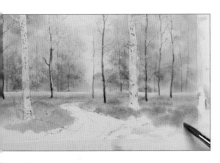

20 Add water towards the foreground and then float in spring green, allowing it to soften in.

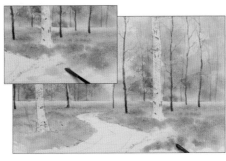

21 Working quickly wet in wet, add cadmium lemon and then the bluebell colour.

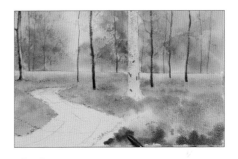

22 Next add the dark green, still working wet in wet.

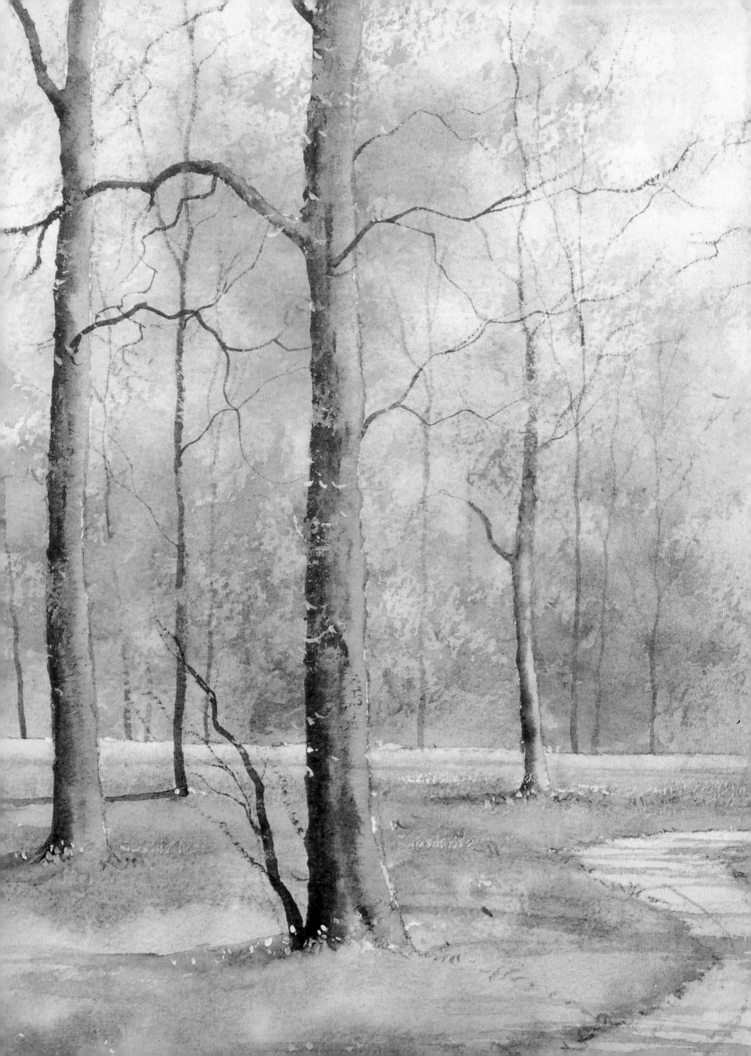

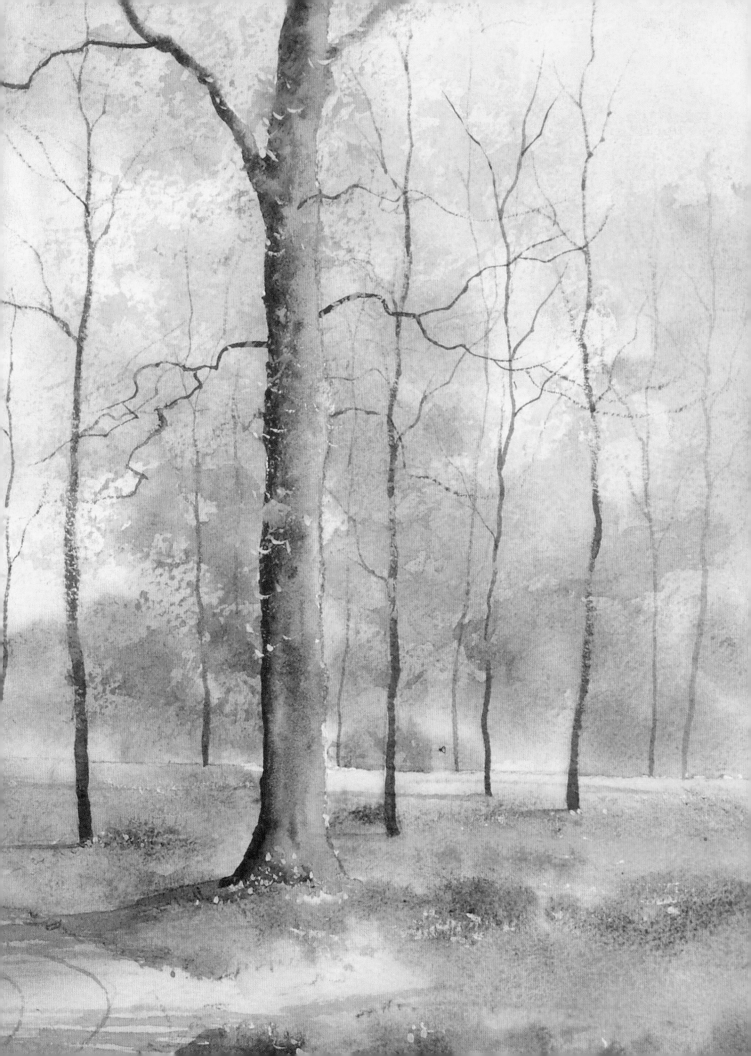

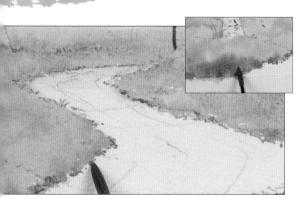

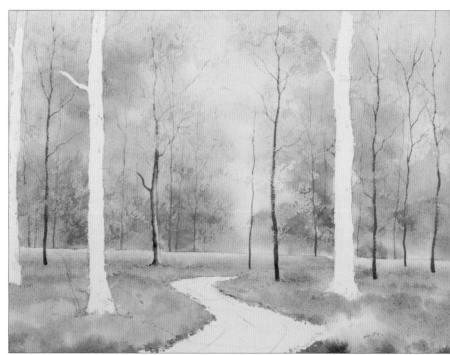

23 Drop the warm colour mixed from raw sienna and burnt sienna into the foreground, along the edges of the path. Use the point of the no. 8 brush to break up the line so that it is not too tidy.

24 Remove all the masking fluid. Tidy up any ragged edges using a wet brush. Mix the colours for the three main trees: a purple from cobalt blue and rose madder; raw sienna and burnt sienna; and a thick mix of dark brown from burnt sienna and ultramarine blue.

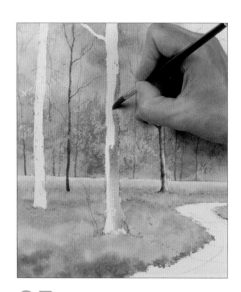

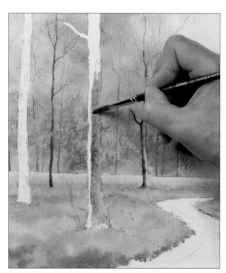

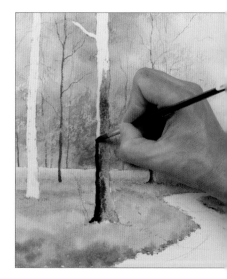

25 Use the no. 8 brush to paint raw sienna and burnt sienna on to the right-hand, light side of a tree.

26 Stop half-way up the tree, as you need to paint wet in wet and there is a danger that the paint will dry too quickly if you complete the trunk in one go. Drop in the purple mix quickly.

27 Still painting wet in wet, paint the shadowed side of the tree with the dark brown. Blend it into the lighter colour so that the trunk looks cylindrical.

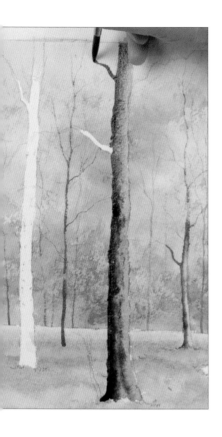

28 Repeat steps 25 to 27 at the top of the tree. Make sure the edge of the trunk is not too neat. Add a branch.

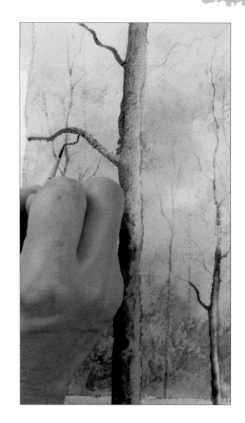

29 Add more branches and extend them with a no. 1 brush.

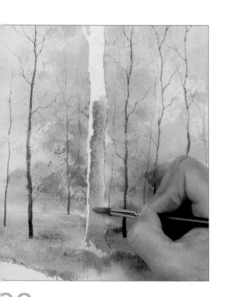

30 Paint the tree to the right of the path in the same way, dropping in raw sienna and burnt sienna, then the purple mix. At this stage also drop in a green mixed from aureolin and cobalt blue to suggest lichen. Paint the third tree in the same way.

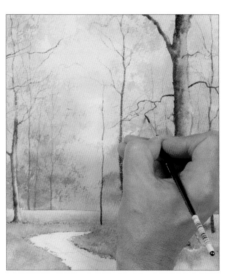

31 Use the no. 1 brush and a dark brown mixed from burnt sienna and ultramarine blue to add more branches and twigs. These are not on the tracing but should be added freely to create a natural look.

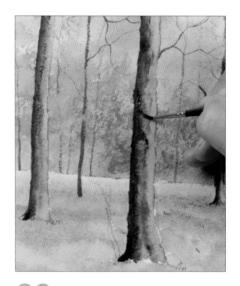

32 Use the no. 1 brush on its side and the dry brush technique to add texture to the bark. Pull the brush down the trunk to create a rough bark appearance.

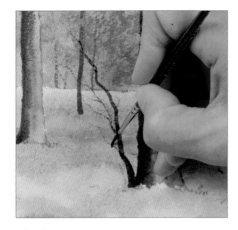

33 Paint the large branch growing from the base of the tree with the dark brown mix and add twigs using the no. 1 brush. Finish off any lines from the tracing at this point and add any other branches and twigs that you feel are needed.

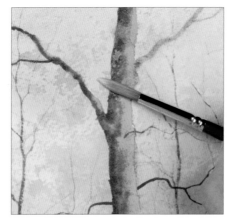

34 Use almost neat cadmium lemon, which is opaque, to paint foliage around and in front of the tree trunks and branches with the no. 8 brush and the dry brush technique. Add a green mixed from aureolin and cobalt blue. Use the brush on its side as shown.

35 Change to the no. 1 brush and pick out individual leaves with quick dashes of cadmium lemon.

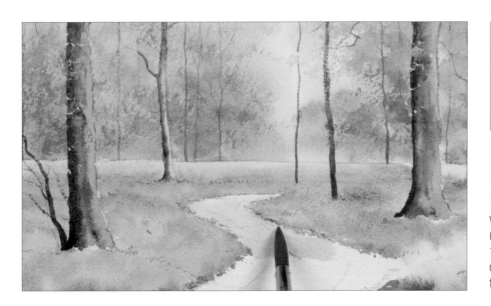

Tip

Keep stepping back from your work to review progress. This can prevent you from becoming too engrossed and overworking it.

36 Wet the path area with clean water. Mix raw sienna with a little rose madder and drop it in with a no. 10 brush, leaving a lighter area in the distance where the path is reflecting the bright light above.

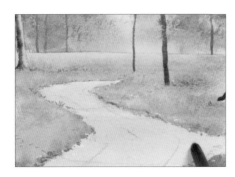

37 Add clean water to the mix in the foreground.

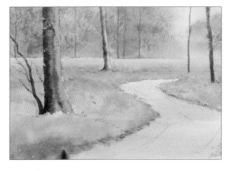

38 Add more raw sienna and rose madder at the very bottom of the picture and extend it into the green beside the path to warm it.

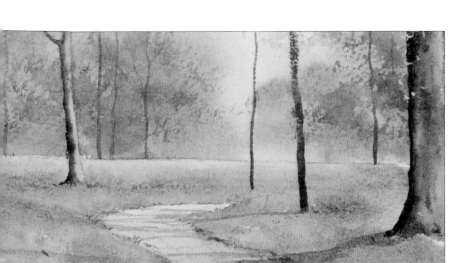

39 Make a mix of cobalt blue and rose madder that is thin enough to be transparent for shadows. Paint shadows from trees across the path with the tip of the no. 4 brush. Remember, the light is coming from the right.

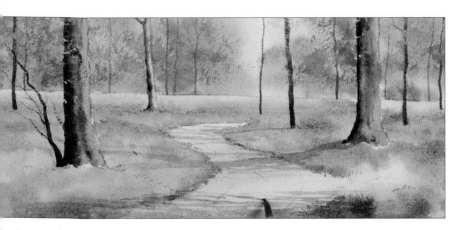

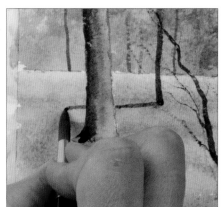

40 Use the no. 8 brush to paint shadows across the foreground. Paint oken lines so that the shadow looks dappled.

41 Soften the base of each tree with the shadow mix and run a line off to the left. Soften the shadows with a damp, clean brush.

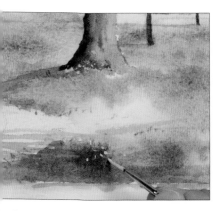

42 Mix a little cobalt blue and balt violet with white gouache and e the no. 1 brush to dot in bluebell ads in the foreground.

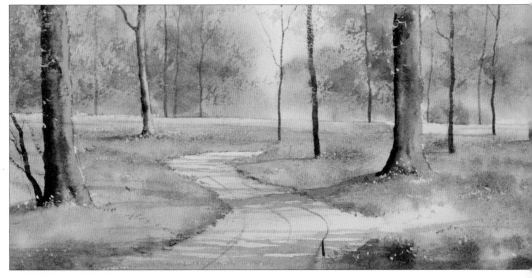

43 Use the no. 1 brush and the shadow colour to paint perspective lines on the path, to lead the eye into the painting.

**Bluebell Wood
taken from:**

Ready to Paint:
Watercolour Trees & Woodlands
Geoff Kersey
978-1-84448-330-3
£8.99

Other Paint It titles:

For the latest information on
our books, or to order a free
catalogue, visit our website:

www.searchpress.com

Search Press

Recommended retail price
UK £3.99 US $5.95
ISBN 978-1-84448-495-9

9 781844 484959

www.searchpress.com

Easy Crochet with Strips of Fabric

Rag Rugs

18 Great Rug Patterns!

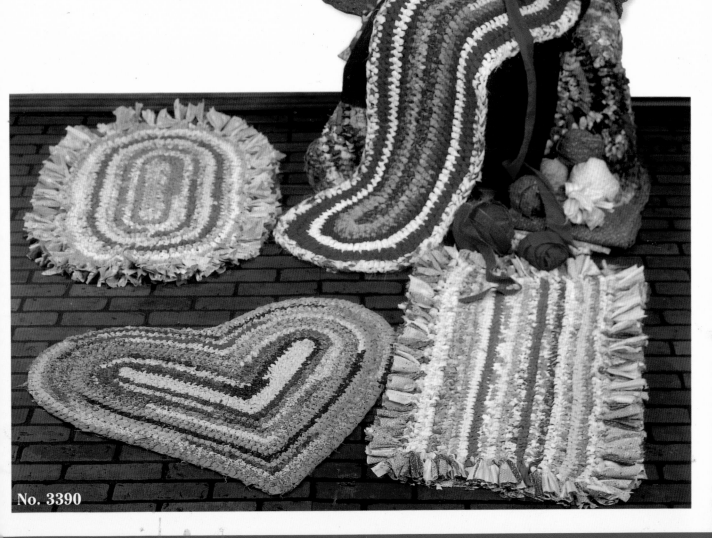

No. 3390

Rag Rugs

Easy Crochet with Strips of Fabric

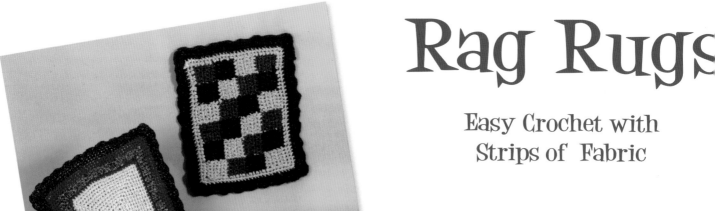

History

The ancient art of carpet weaving reached its height in Turkey and Central Asia. All carpets were handmade until 1841, when a man named Bigelow introduced the power loom. Outstanding examples of handmade rugs were made in 17th century France and in 18th century England. Rugs have been fabricated from wool, velvet, chenille, rags, straw and fiber.

Materials

Rag Rug projects require only cotton fabric and large crochet hooks. The supplies are inexpensive and can be found at your local craft, fabric or variety store.

For a color catalog featuring over 200 terrific 'How-To' books, **visit www.d-originals.com**

© 2006 DESIGN ORIGINALS by *Suzanne McNeill*, 2425 Cullen St, Fort Worth, Texas 76107, U.S.A., 817-877-0067 • www.d-originals.com